COLORED PENCIL FUN

Acknowledgement

The authors, Carolyn Davis and Charlene Brown, would like to thank
all of the following for their patience and support —
Sally Marshall Corngold, Jim Paine, Kassie and John Raley,
and, of course, Sydney Sprague, editor,
and the rest of the wonderful staff at Walter Foster Publishing, Inc.

ISBN 1-56010-058-6

Introduction

Welcome to the fun world of colored pencils! While most of us have used colored pencils before, few of us have used them as an art medium. This is your chance to learn how to use colored pencils in a variety of creative projects. You can use colored pencils in ways you have probably never even thought about before.

You will learn how to use colored pencils on a variety of papers — smooth and textured — and in an array of colors. Colored pencils also work well on dark papers, which is a nice change from many other art media. Did you know you can even create a watercolor look with colored pencils? Of course, as we say in all our books, the most important lesson we can teach you is that art is fun! Experiment with various types of colored pencils and papers. Every time you do, you will not only learn something new, but your art skills, as well as your tactile and visual skills will improve.

Note — the directions in this book tell what types of colored pencils and papers we chose to use for our examples, but you can use any combinations you want — it's your art!

Remember, **have fun** and use your imagination!

Glossary

BLEED — When watercolor pencils spread out and/or run together, creating various effects, shades or even other colors. For example, when yellow and blue bleed together they make green.

FLEXIBLE — Something that is able to bend without breaking. In this book, we use the word "flexible" to describe bendable wire.

HIGHLIGHT — To add white or other light colors to a specific area of a drawing to create light reflections.

HUE — The name of a color or a shade of a color. This helps us to distinguish between variations of the same color. For example, violet is a hue of purple.

INTENSITY — The purity or strength of a color. Adding white, black or other colors to a color changes the color's intensity.

MEDIA — Various materials that are used to create art. Examples: watercolor paints, oil paints, felt pens, pencils, colored pencils, etc.

PRIMARY COLORS — Red, Blue and Yellow.

SECONDARY COLORS — The colors created when any two primary colors are mixed. Purple, green and orange are secondary colors.

SHADING — The use of black or another dark color to create shade or shadows in a picture.

TEXTURE — The way something looks or feels. An object can have a furry texture, a smooth texture, a rough texture, etc. In art, adding texture makes the object look more realistic.

Contents

Materials

WATERCOLOR PENCILS

Watercolor pencils are similar to regular colored pencils, but they are water-soluble and can be used with water to create a watercolor paint effect.

COLORED PENCILS

Colored pencils come in every color of the rainbow. They can be purchased one at a time or in sets.

SCISSORS

ERASER

RULER

A ruler is used for measuring and drawing straight lines.

Materials, continued

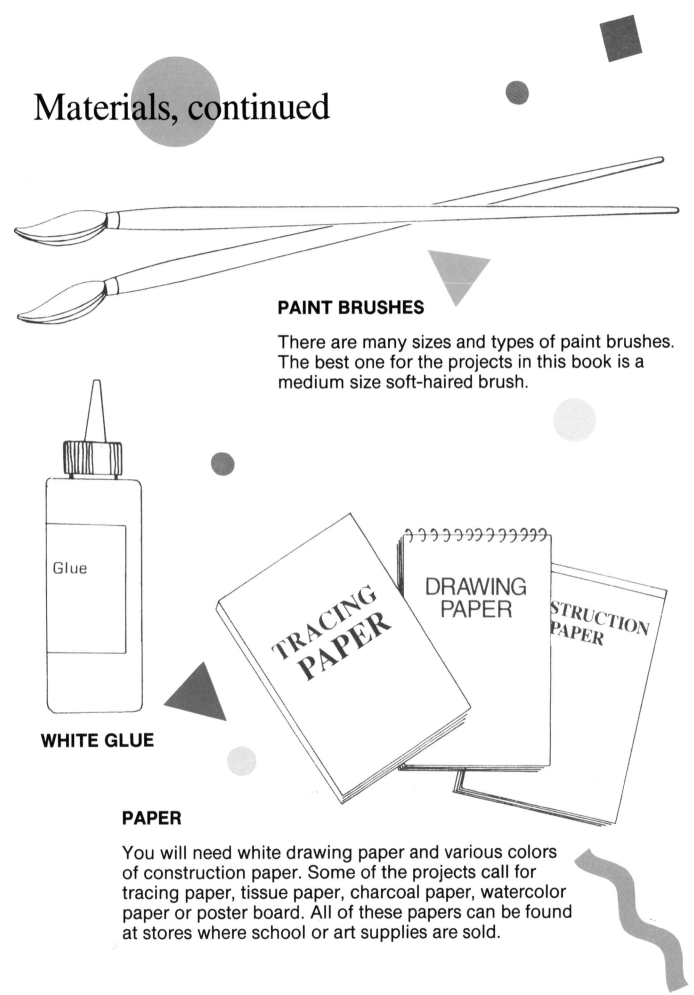

PAINT BRUSHES

There are many sizes and types of paint brushes.
The best one for the projects in this book is a
medium size soft-haired brush.

Glue

WHITE GLUE

TRACING PAPER

DRAWING PAPER

STRUCTION PAPER

PAPER

You will need white drawing paper and various colors
of construction paper. Some of the projects call for
tracing paper, tissue paper, charcoal paper, watercolor
paper or poster board. All of these papers can be found
at stores where school or art supplies are sold.

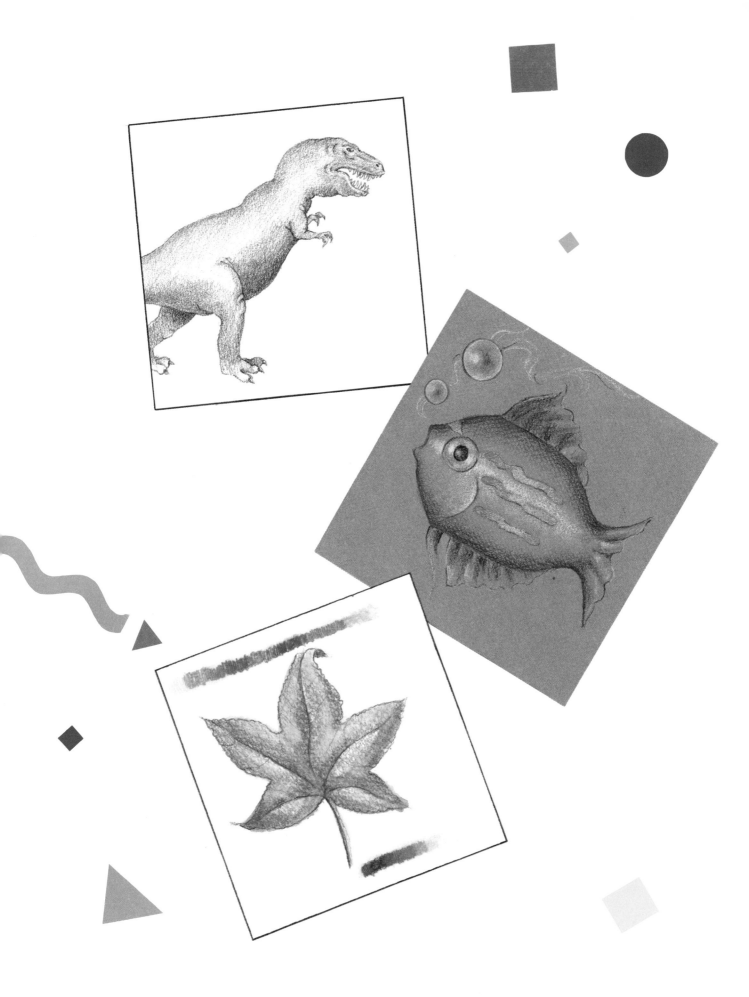

1
COLORS AND TEXTURES

Colored pencils are available in every color of the rainbow and then some. They can be used to create many types of textures. In this chapter we encourage you to experiment with different types of colored pencils on many different kinds of paper. You may like using watercolor pencils best because they can be used to create an effect that looks like a watercolor painting.

Make a variety of color wheels. By using color wheels, you can see how colors blend together and how they look next to each other. And, as you probably know by now, color may be the most important factor in art, so learning about color will help in all your art projects.

Experimenting, such as we have done in this chapter, is the best way we know to learn about texture and color. Remember, **have fun** and use your imagination. Experiment! You might create something you've never even imagined!

Make A Color Wheel

The best way to learn about colored pencils is to experiment. Make a color wheel. Have fun!

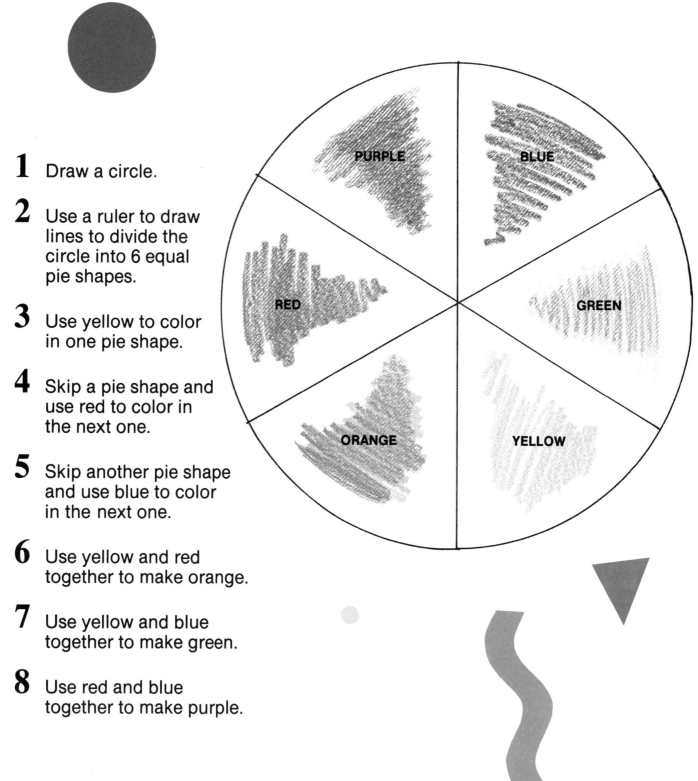

1 Draw a circle.

2 Use a ruler to draw lines to divide the circle into 6 equal pie shapes.

3 Use yellow to color in one pie shape.

4 Skip a pie shape and use red to color in the next one.

5 Skip another pie shape and use blue to color in the next one.

6 Use yellow and red together to make orange.

7 Use yellow and blue together to make green.

8 Use red and blue together to make purple.

Creating Colors

Colored pencils can be used together to make different colors. Look at the various hues of each of the following colors:

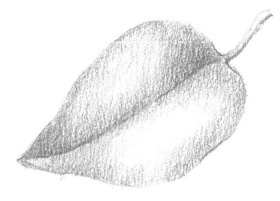

MORE YELLOW **MORE BLUE**

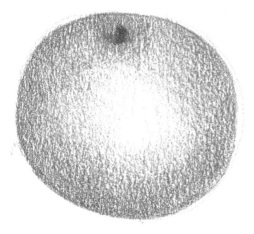

MORE YELLOW **MORE RED**

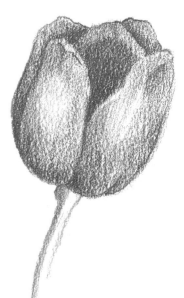

MORE RED **MORE BLUE**

Creating Intensity With Colored Pencils

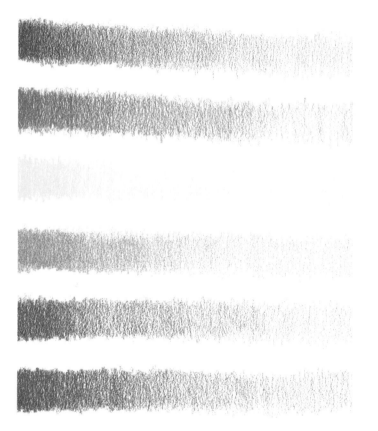

When using colored pencils, use less pressure to decrease the intensity or to make the color lighter. More pressure makes a color more intense or darker. Darker colors make objects appear farther away and lighter colors make objects appear closer. Remember these techniques when you are coloring your projects.

1 Use light pencil to draw your design. (You may want to refer to our *Drawing Fun* book.)

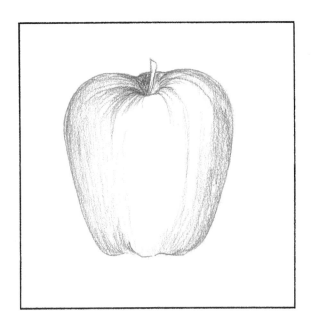

2 Using colored pencils, draw over the lines you want to keep.

3 Erase any light pencil lines that show.

4 Use colored pencils to color the solid areas of the design. Use less pressure for lighter shading (close-up objects) and more pressure for darker shading (distant objects).

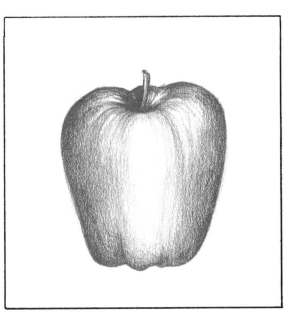

Change Values
By Adding Black

You can create different moods by gradually adding black to a color. Remember this technique when you do your projects. (You may want to refer to our *Drawing Fun* or *Color Fun* books.)

Green

Blue

Purple

Red

Orange

Yellow

Dinosaur

Now we will use black to shade this dinosaur. The black creates depth and makes the dinosaur look more realistic.

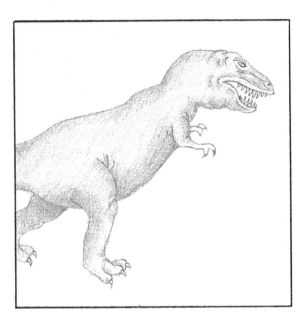

1 Draw the basic shape of the dinosaur in light pencil.

2 Using colored pencils, draw over the lines you want to keep.

3 Erase any light pencil lines that show.

4 Use colored pencils to color in the dinosaur.

5 Now use black over the darker areas to create a more intense feeling. Use light pressure for lighter shadows and more pressure for darker shadows.

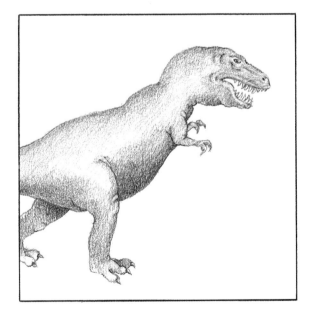

Colored Pencils On Colored Paper

Using colored pencils on colored construction paper or charcoal papers will create a variety of effects.

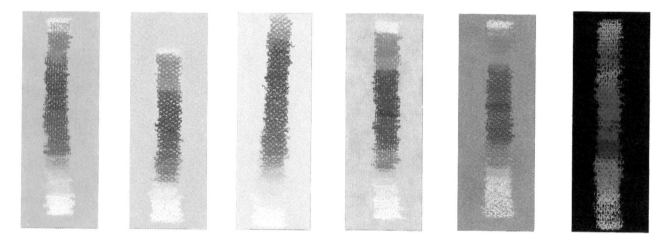

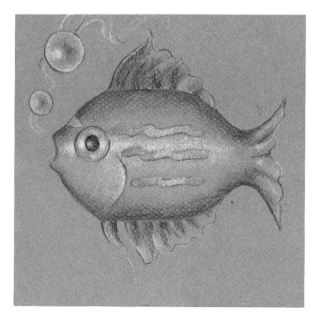

For this example on light colored paper we used white for highlighting and dark colors for shading.

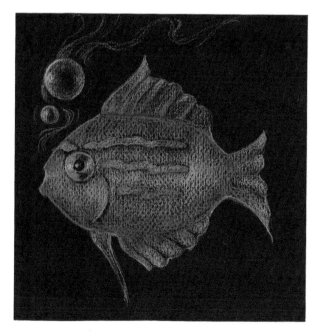

For this example on black paper we used white for highlighting and medium colors for shading.

Watercolor Pencils On Watercolor Paper

Note — Watercolor pencils are not regular colored pencils. You can purchase them at most stores that sell art or school supplies.

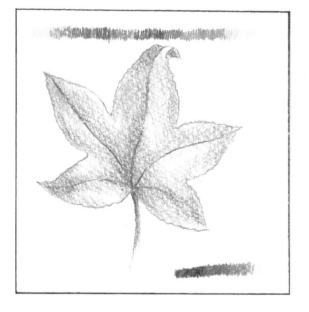

1 Use watercolor pencils to draw a fun design on watercolor paper. We drew a fall leaf.

2 Color the solid areas of your design with watercolor pencils. Use colors that will blend well together.

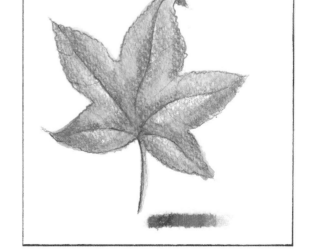

3 Use a wet paint brush to carefully brush over the areas that you want to bleed. See how the colors blend and change.

What fun!

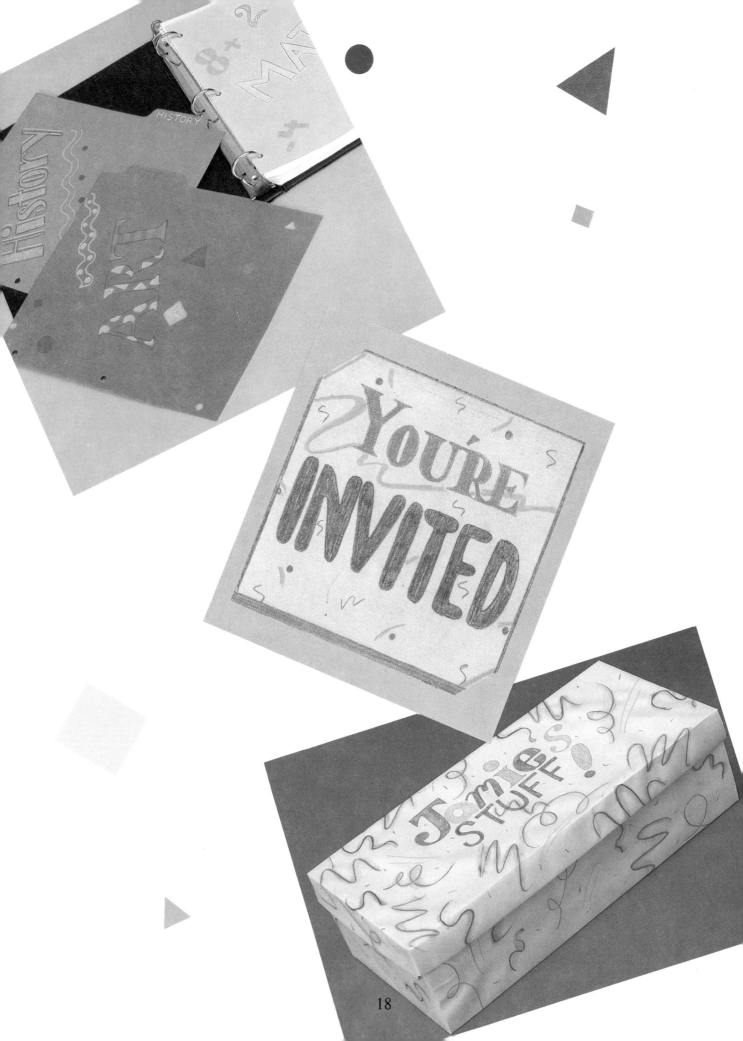

2 LETTERING

One way to use colored pencils is for lettering. We want you to be very creative when lettering. You may want to use your colored pencils to write in script. Or, how about trying an outline style using different colors for the insides? (See pages 20 through 23 for examples.)

In this chapter we show you how to make different types of letter styles. You can even combine the styles to make fun designs. Use your imagination!

Once you see how much fun lettering can be with colored pencils, you will want to make your own greeting cards, posters, and more. Remember, these are just examples — you can create any style you want. And, you can use any colors you want and say anything you want (well, almost anything).

Remember — use your imagination and **have fun!**

Colored Pencil Lettering

Colored pencils are great for lettering. Try the techniques shown here to letter your name. You might see fun lettering styles in magazines or other books you might want to try. Experiment — lettering can be fun!

Here are four basic styles of lettering:

SERIF

A B C D E F G H I J
K L M N O P Q R S
T U V W X Y Z
a b c d e f g h i j k l
m n o p q r s t u v w
x y z

SANS SERIF

A B C D E F G H I J
K L M N O P Q R S
T U V W X Y Z
a b c d e f g h i j k l
m n o p q r s t u v w
x y z

ITALIC

A B C D E F G H I J
K L M N O P Q R S
T U V W X Y Z
a b c d e f g h i j k l
m n o p q r s t u v w
x y z

SCRIPT

A B C D E F G H I J K L
M N O P Q R S T U V W
X Y Z
a b c d e f g h i j k l m n o
p q r s t u v w x y z

Letter Your Name

1 Use light pencil and a ruler to draw horizontal guidelines. Letter your name between the lines.

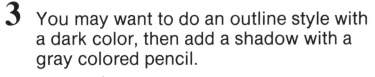

2 Trace over the lines you want to keep with colored pencils.

3 You may want to do an outline style with a dark color, then add a shadow with a gray colored pencil.

4 When you have created the look you want, carefully erase the pencil guidelines.

Combine Letter Styles

Now we will combine letter styles to create some fun designs. Use your imagination!

Various Letter Styles:

SANS SERIF WITH SHADOW

SANS SERIF ITALIC

SANS SERIF, WIDE AND THIN

SERIF OUTLINE

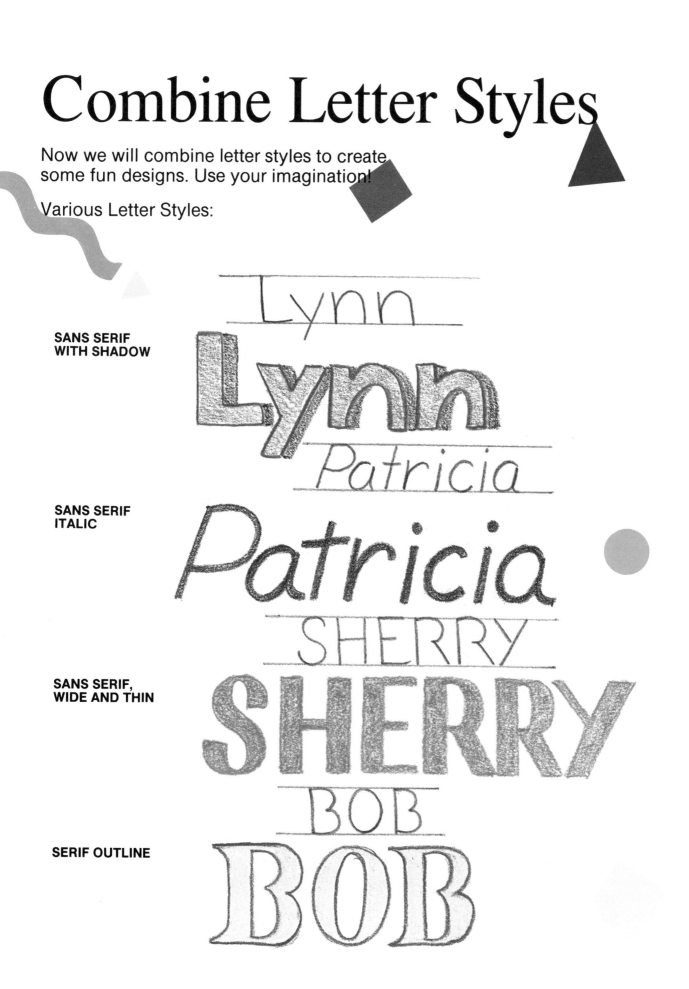

**SERIF ITALIC,
WIDE AND THIN**

SCRIPT OUTLINE

SCRIPT WITH SHADOW

FANCY SCRIPT

**COMBINED
LETTER STYLES**

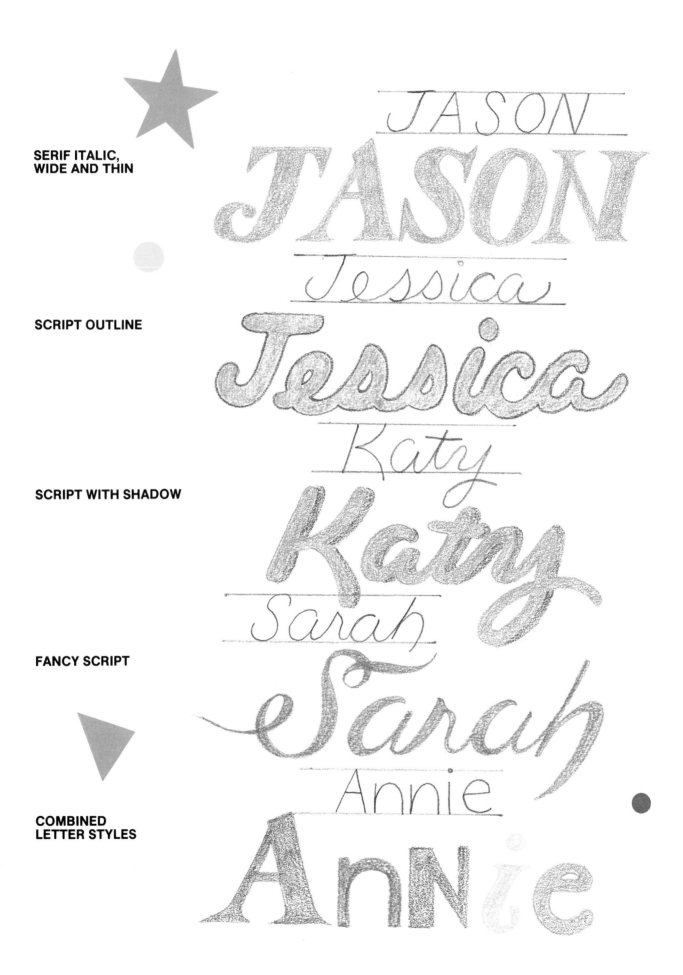

JASON

JASON

Jessica

Jessica

Katy

Katy

Sarah

Sarah

Annie

Annie

23

Colorful Invitations

Use a variety of letter styles and colors to make fun invitations. You can make invitations for any kind of party.

1 After you decide what you want to say, use light pencil and a ruler to draw horizontal guidelines on a piece of drawing paper, as shown.

2 Use light pencil to letter your invitation (use the horizontal lines as guides). Use any letter style you want. You may even want to copy a card you have received in the past.

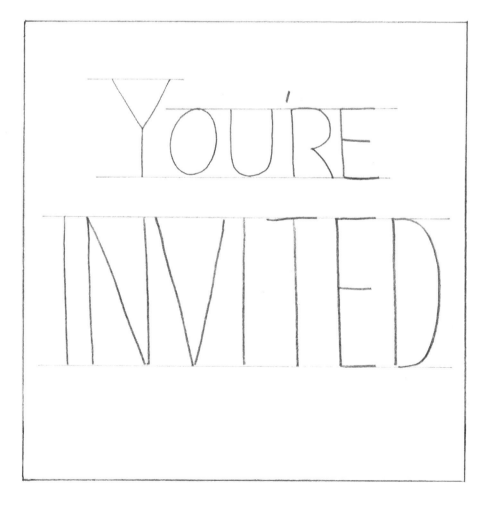

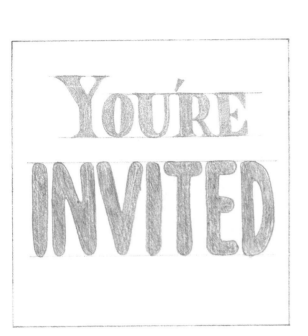

3 Lay a piece of tracing paper (or any paper you can see through) on top of the drawing paper. Then use colored pencils to trace over the words. What colors would be fun?

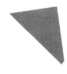

4 If you choose, you can decorate your invitation by adding spots of color.

5 Glue the tracing paper to a folded piece of construction paper to make a card.

6 Use colored pencils to letter the information about the party on the inside of the card.

Who could resist this party invitation?

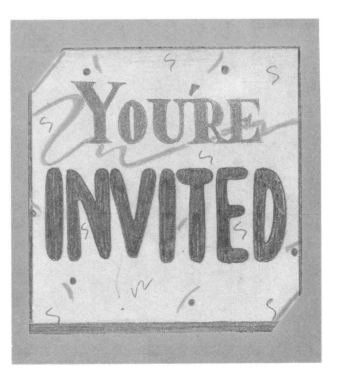

Notebook Dividers

Use colored pencils to make colorful notebook dividers. It's fun and practical!

1 Cut out several nine by eleven inch sheets of construction paper. You may want to make a different colored divider for each one of your classes.

2 Use light pencil and a ruler to draw horizontal guidelines on each piece of paper.

3 Use light pencil to letter the name you want on each divider. (Use the horizontal lines as guides.) Use any letter styles you want.

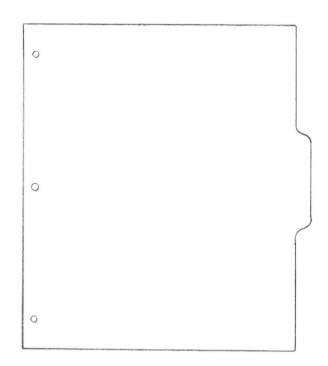

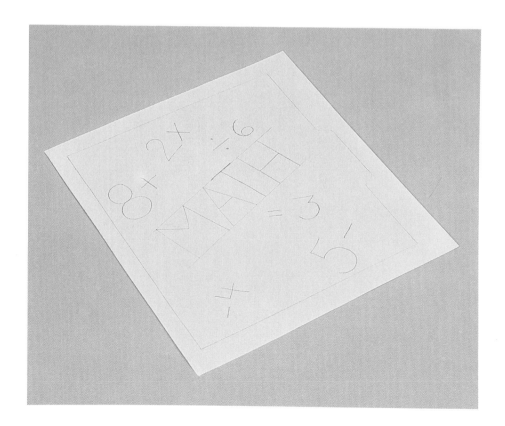

4 Use colored pencils to trace over the names. Use any colors you want.

5 When you have created the look you want, carefully erase the pencil guidelines.

6 If you choose, you can decorate your notebook dividers by adding designs of color.

Now you're ready to use your one-of-a-kind notebook dividers!

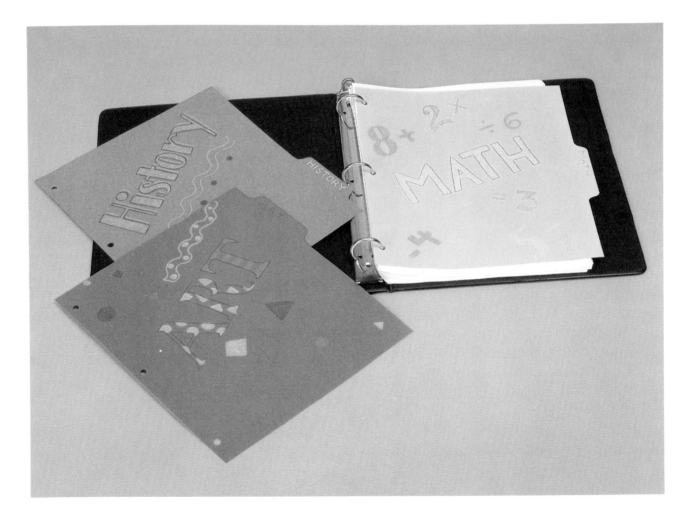

Toy Box

We used a shoe box to make this fun toy box. It can be used for extra toy and game pieces such as marbles, checkers, doll accessories — anything!

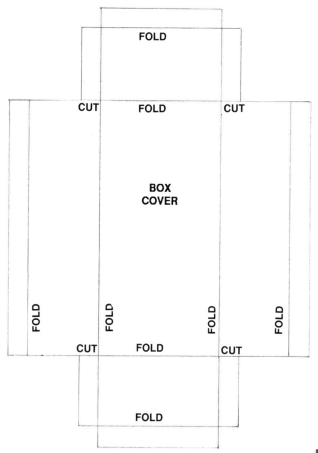

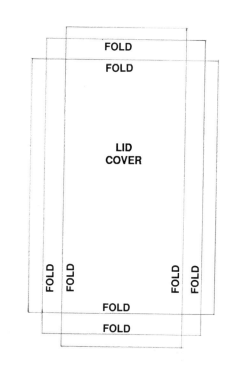

1 Find a box that will hold your toy and game pieces. (Be sure to get permission if the box does not belong to you.)

2 Use a ruler to measure the box, then cut out a piece of construction paper the width and length you need to cover it. (Check it by wrapping the paper around the box.)

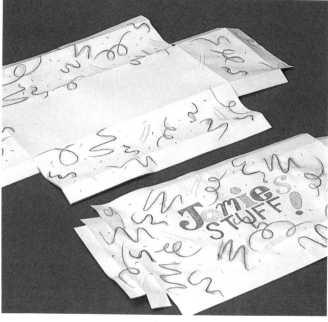

3 Lay the paper flat. Use light pencil to draw horizontal guidelines on the part of the paper that will be on the outside of the box.

4 Use light pencil to letter the words between the horizontal lines. Use any letter styles you want.

5 Use colored pencils to trace over the words. Use any colors you want.

6 When you have created the look you want, carefully erase the pencil guidelines.

7 You may choose to decorate your box cover by adding colorful designs. We used watercolor pencils (see page 32).

8 Now glue the paper covers to the box and the lid.

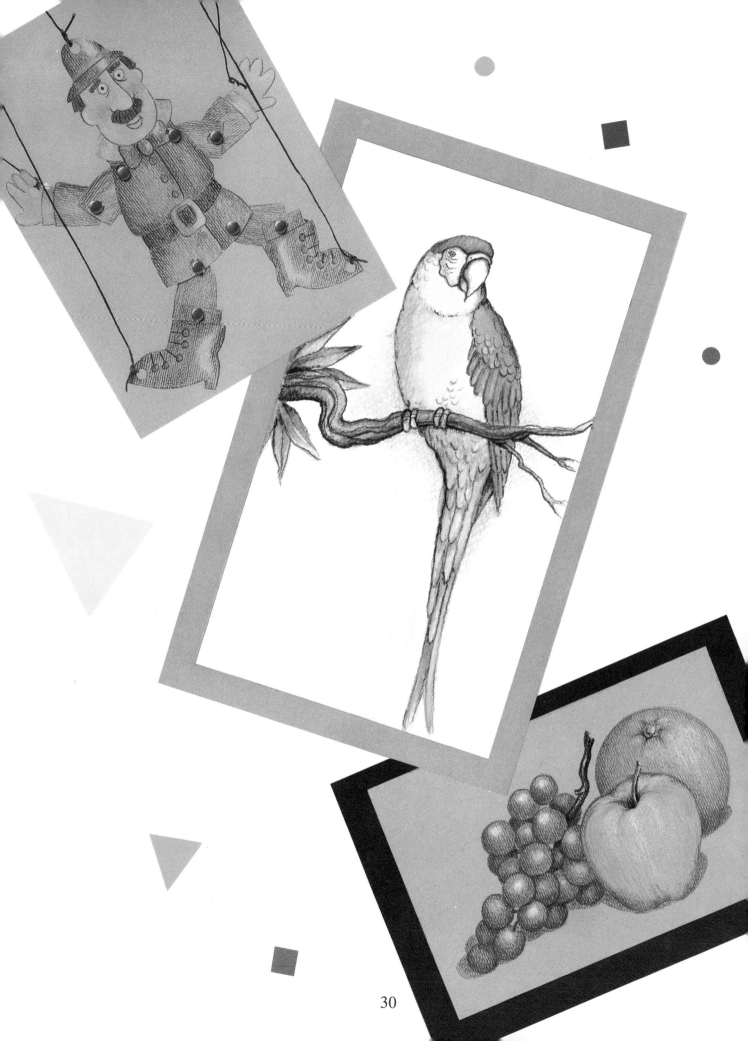

3
MIXED MEDIA

In this chapter we experiment with mixed media techniques. We make some great projects by using various art media and by being creative. We show you how to make both two- and three-dimensional art projects using colored pencils and your imagination.

The first project is a two-dimensional drawing of a tropical macaw. (You don't know what a tropical macaw is? See page 32!) You can draw any animal or anything else you can dream up. We also make a three-dimensional, abstract art mobile and a funny man puppet. What other kinds of puppets can you make with colored pencils?

Remember, whatever you decide to make, use your imagination and **have fun!**

Tropical Macaw

We used watercolor pencils to make this color-
ful macaw. This technique can be used for any
subject you want — use your imagination!

1 Use light pencil to draw the macaw
on a piece of watercolor paper. (You
may want to refer to our *Drawing
Fun* book.)

2 Trace over the light pencil drawing
with colored pencils.

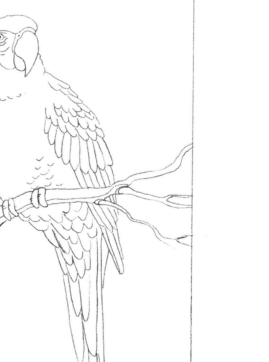

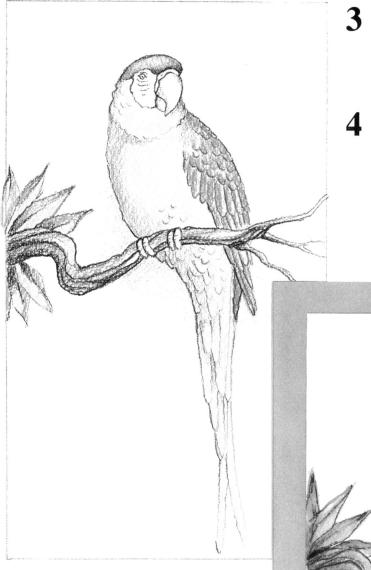

3 Now color in the solid areas of the macaw with the colors you think will look best and that will blend together nicely.

4 When you have created the look you want, carefully erase any light pencil lines that show.

5 Use a paint brush to carefully brush water over the areas that you want to bleed. See how the colors blend and change!

6 You may choose to frame your drawing by gluing it onto a colorful piece of construction paper.

What a fun way to bring a macaw to life!

Colored Pencils On Charcoal Paper

We used colored pencils on colored charcoal paper to draw this delicious-looking fruit.

1 Use light pencil to draw the fruit on a piece of charcoal paper. You can copy our example, copy from a book or magazine, or look at real fruit. (You may want to refer to our *Drawing Fun* book.)

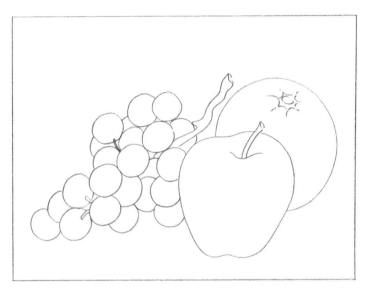

2 Use colored pencils to trace over the light pencil lines. Try to use colors that look like the natural colors of the fruit.

3 Using the same colors, color in the fruit.

4 Use 3 or 4 colors for each piece of fruit to create texture and shape. We added red to the outer edges of the orange, yellow in the middle, and white for the highlight.

5 We added dark green and blue to the shaded areas of the apple and yellow to the inside area of the apple. Once again, we added white for highlight.

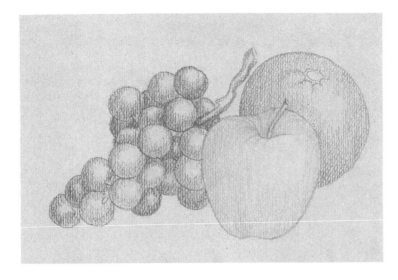

6 We added red and blue to each grape. We also highlighted them with white.

7 When you are finished coloring the fruit, shade the fruit. Always shade on the same sides of the fruit — what you do for one, you do for all. We used complementary colors (from the color wheel) for the shading — blue for the orange, yellow for the grapes, and purple for the apple.

8 You may choose to frame your drawing by gluing it onto a colorful piece of construction paper.

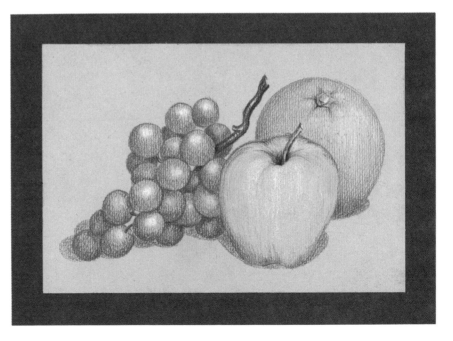

35

Gift Wrapping Set

1 Choose a piece of construction paper large enough to cover a paper towel tube.

2 Also choose some small pieces of construction paper for your gift tag and to cover the ends of the tube.

3 Use colored pencils to draw squiggles and designs all over the pieces of paper. Use bright, fun colors!

4 Stand the tube on end on one piece of paper and trace around the edge. Then trace the end of the tube on another piece of paper. These circles will cover the ends of your tube.

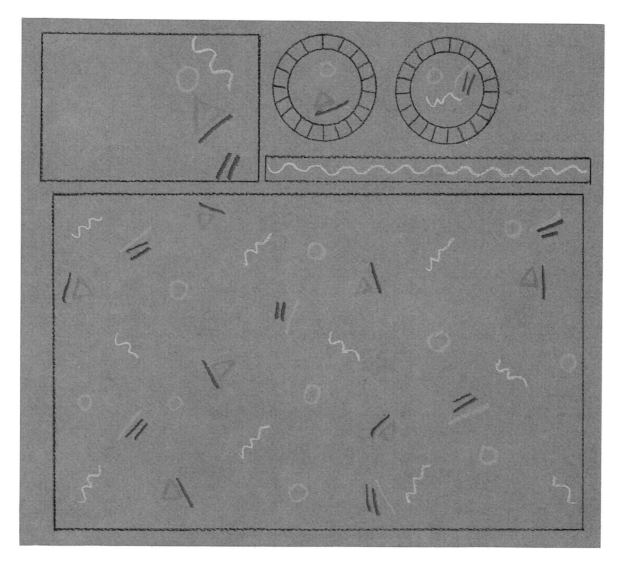

36

5 Cut out the two circles ½ inch wider than the pencil lines, as shown. Cut notches all the way around the circles, as shown.

6 Fold and glue one circle to one end of the tube.

7 Fold the notches of the second circle and glue a thin strip of paper around them to form a cap.

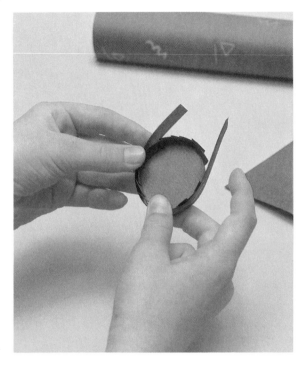

8 Wrap the large piece of paper around the tube and glue in place.

9 Cut out and fold the gift tag.

10 Put a gift such as a scarf or another flexible item into the tube.

11 Write your message on the gift tag and hang it from the gift with ribbon, string or thread.

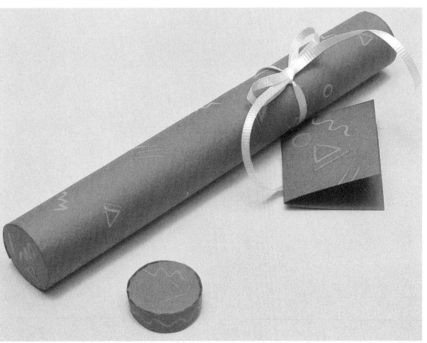

Funny Man String Puppet

This fun puppet was put together with paper fasteners, strung with string and controlled with sticks, as shown.

1 Using light pencil on a piece of tan colored drawing paper, draw the head, body, legs, arms, and feet.

2 Use colored pencils to trace over the pencil lines you want to keep.

3 Use colored pencils to draw clothes. (We used two or three colors for each piece to make them colorful and fun.)

4 Cut out the parts and glue them onto a piece of poster board.

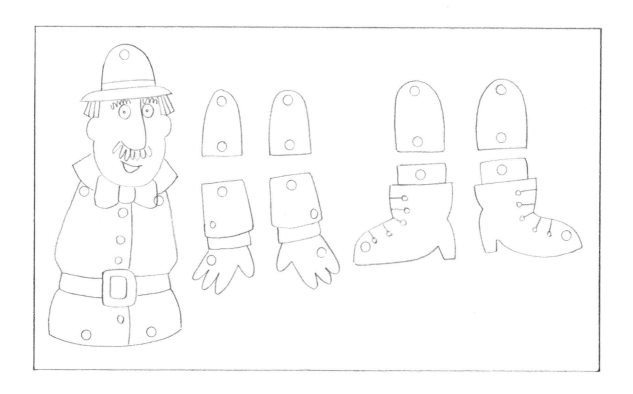

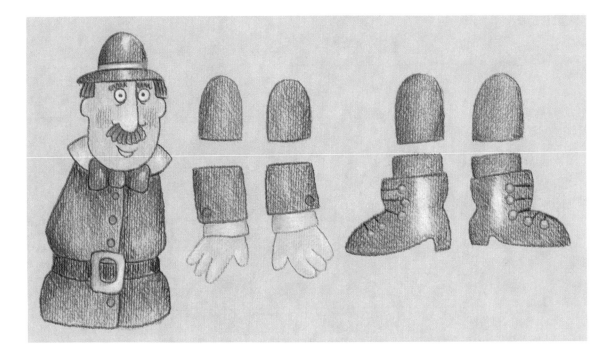

5 Cut the poster board around the construction paper parts.

6 Punch a hole at the top of the head, on each hand, and at the elbows, shoulders, hips, knees and feet.

7 Attach the pieces together with paper fasteners (called "brads").

8 Put string through the remaining holes and gently, but securely, tie the string.

9 Tie the other ends of the string to two sticks or, if you prefer, to your fingers (you may need to ask a friend to help you do this).

Get ready for your puppet to come to life!

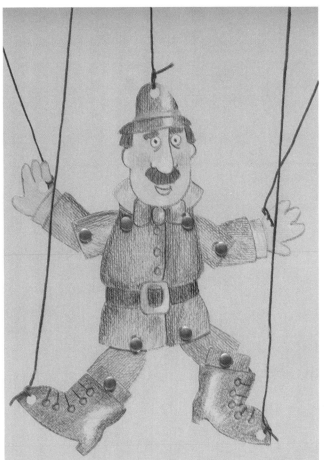

Abstract Art Mobile

This colorful mobile was made with tissue paper and thin, flexible wire. Be sure to ask permission if the wire doesn't belong to you.

1 Bend pieces of flexible wire into fun shapes and tape the ends together.

2 Use light pencil to trace each shape on a piece of tissue paper.

3 Use colored pencils to color the tissue paper shapes with fun colors. We used several colors on each shape.

4 Cut out each shape.

5 Glue the paper shapes to the matching wire shapes.

6 Punch a hole in the top of each shape and attach a piece of string to each one.

7 Tie the other ends of the strings to two straight wires, as shown. Make sure the weight is balanced so the mobile will hang straight.

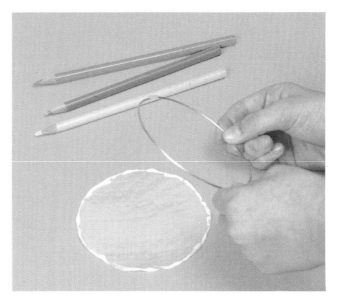

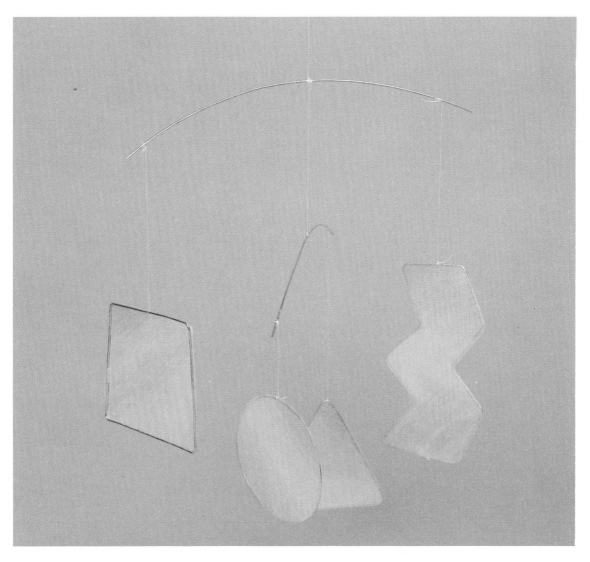

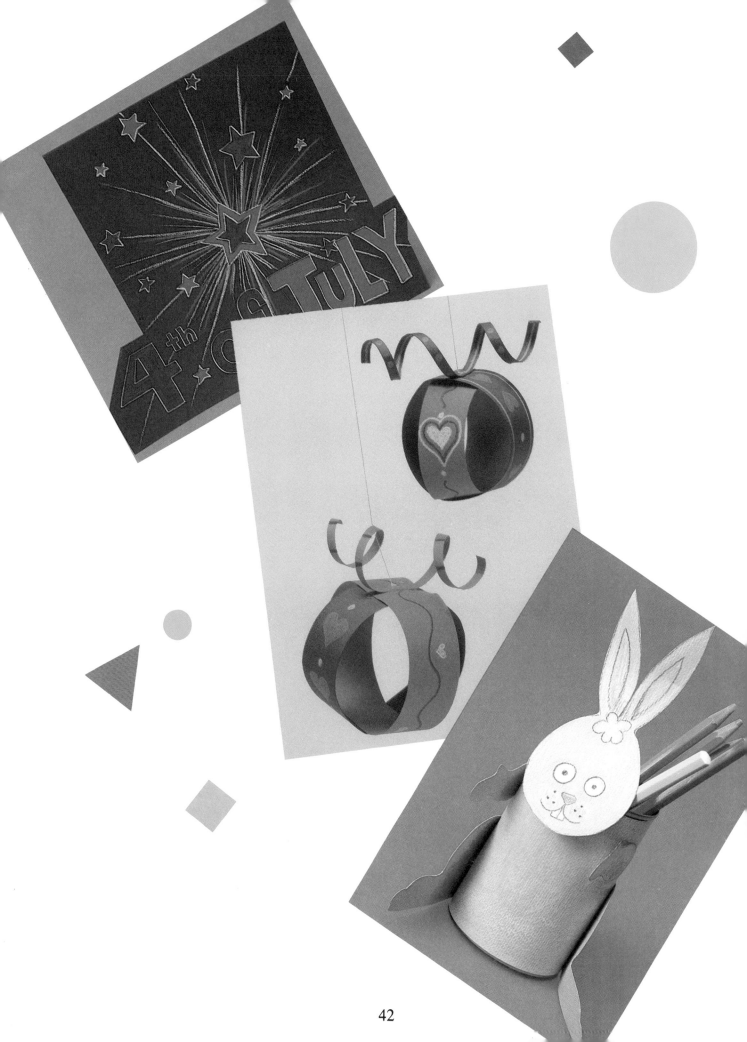

4
HOLIDAY FUN

One of the best times to create art projects is when we're home from school (or work) because of a holiday. In this chapter we make decorative holiday ornaments for Valentine's Day (but you can make them in any colors, for any holiday).

We are very excited about our Halloween movie box that makes you director, producer and writer of your own movie. (Once again, even though we used Halloween, you can make the movie for any holiday or any occasion.) We have lots of other fun ideas for holidays, too. How about a bunny pencil holder for Easter? Or, you might want to try our Fourth of July table decoration.

Our holiday projects not only give you a chance to work with colored pencils, paper, glue and construction paper, but they also give you a chance to use your imagination by creating different projects to do during your time off from school.

Remember, the very best presents or surprises are ones that have been handmade — so **have fun!**

Fun Holiday Decorations

You can use these same directions to make decorations for any holiday or birthday. We used purple, pink and white for Valentine's Day.

1 Experiment with different holiday designs and colors by drawing them on three separate pieces of construction paper.

2 Which designs do you like best? We chose to draw tiny hearts on purple paper.

3 Cut each piece of your decorated paper into even strips.

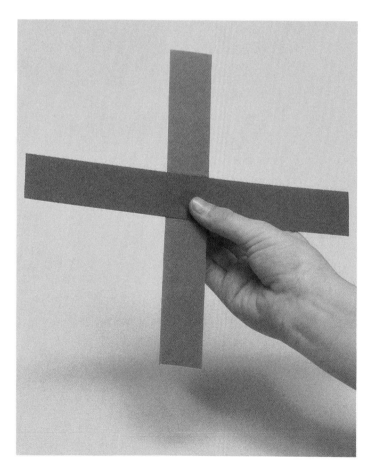

4 Glue or staple two strips together to make a cross shape, as shown.

5 Glue or staple the ends of the paper strips together to form circles, as shown.

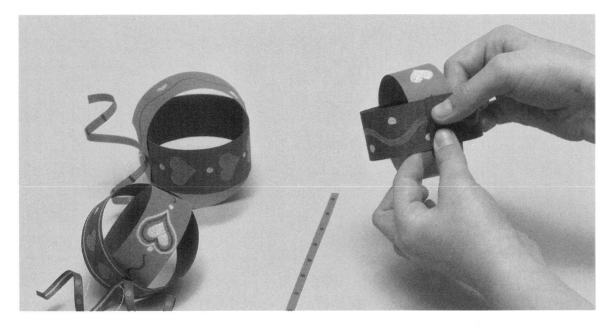

6 We added a decorative top by curling dotted, thin strips of paper around a pencil and gluing them to each ball.

7 If you choose, you can string several balls together to make a colorful streamer.

Now you are ready for some holiday fun!

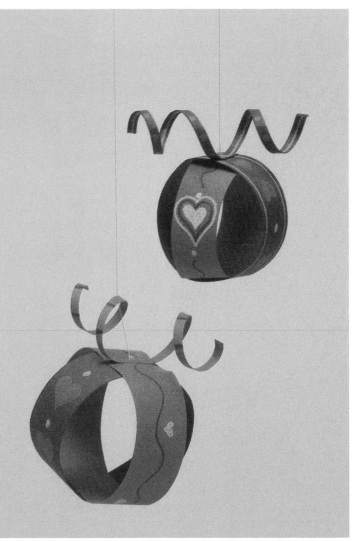

Bunny Pencil Holder

You can make this bunny pencil holder as a gift for Easter. People will keep this fun present because bunnies are fun all year long! You will need a small, clean can or container with one open side (such as a soup can).

1 Cut out a piece of colored construction paper the width and length needed to cover the can. This will be the bunny's body.

2 Draw the bunny parts on another piece of colored construction paper, as shown.

3 Use colored pencils to draw the details, such as the eyes, nose, mouth, ears, and fur on the shapes.

4 Cut out the shapes.

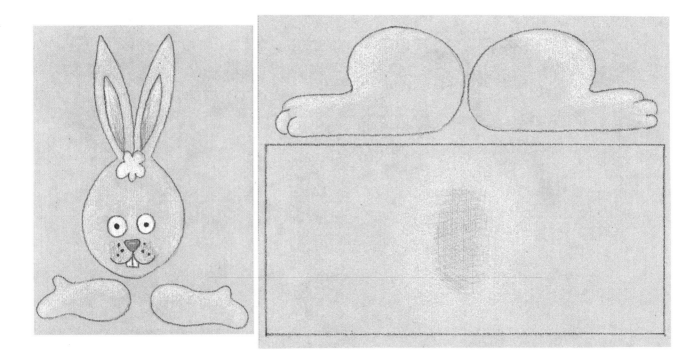

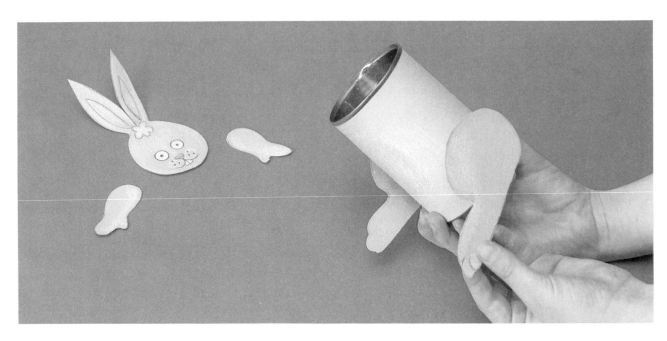

5 Wrap the bunny's body around the can and glue it. Hold the body in place until the glue dries.

6 Glue the front feet to the container. Hold the feet in place until the glue dries.

7 Glue the back feet to the container. Hold them in place until the glue dries.

8 Glue the head to the container. Hold it in place until the glue dries.

Now you're ready for a fun, happy Easter!

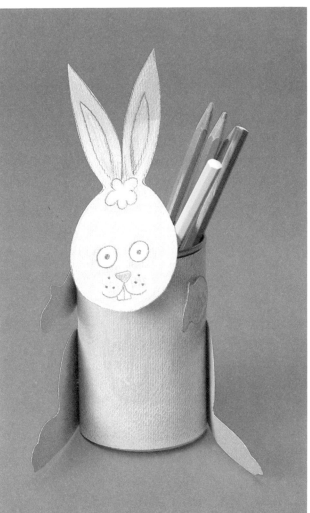

Merry Christmas Card

We used watercolor pencils to make this pretty Christmas card. You can make cards for any occasion — use your imagination!

1 Plan your project carefully. Decide what your card should say and what it should look like. We decided to make a Christmas card.

2 Draw different designs on scrap paper. Try different colors. Which one do you like best?

3 Use watercolor pencils to draw your design on a piece of watercolor paper.

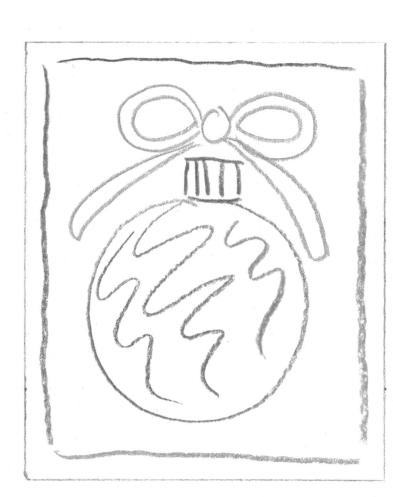

4 Using a slightly wet paint brush, brush water over the areas you want to bleed. See how the colors blend and change!

5 Cut out the drawing and glue it onto a folded piece of colorful construction paper.

6 Write a special message on the inside of the card using the lettering techniques described in chapter two.

"In this special season we give thanks for all our friends"

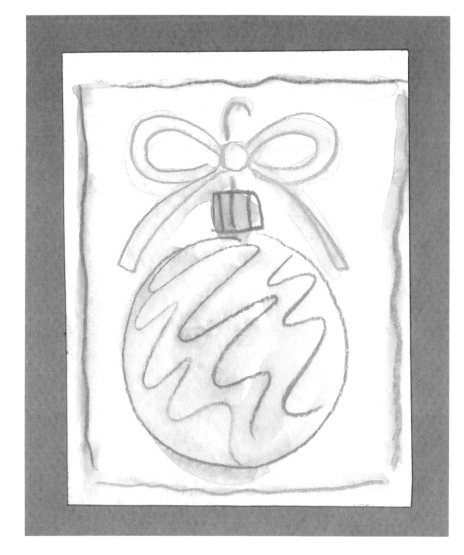

Fourth Of July Table Decoration

We made a fun Fourth of July table decoration with colorful fireworks and stars. Can you think of designs to make for other holidays?

1 Using colored pencils, draw a design on a colorful piece of construction paper. We chose to draw fireworks in Fourth of July colors. (Notice how the bright red and blue look on the black paper.)

2 Carefully cut out your design.

3 To make your design stand up, glue a folded piece of paper to the back, as shown.

Now you're ready for a Fourth of July picnic!

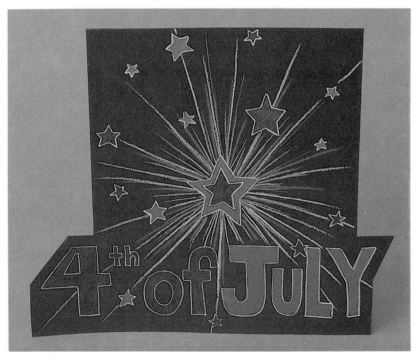

Halloween Movie Box

1 Write out your story. We chose a simple story about a witch. The first time you do this project you should keep your story simple. (You may want to refer to our *Comic Strip Fun* book.)

2 Draw your story, frame by frame, on a long, narrow piece of tracing paper (or any paper that will allow light to show through). Draw the frames on top of one another rather than side by side. Tape strips of paper together to make it long enough. The paper should be about 3½ inches wide so that it fits easily into a shoe box, as shown. Leave an inch of blank paper at the beginning of the strip and at least 12 inches at the end so you can wrap them around the handles.

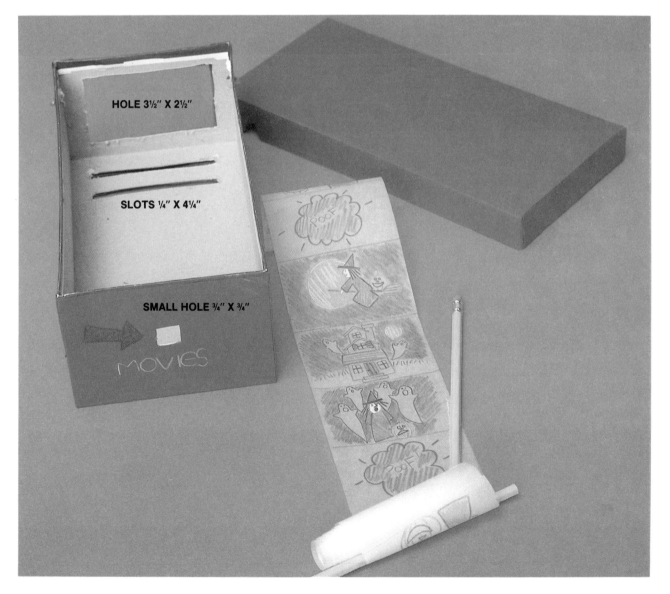

HOLE 3½" X 2½"

SLOTS ¼" X 4¼"

SMALL HOLE ¾" X ¾"

MOVIES

3 Color in your movie strip with colored pencils.

4 Prepare your movie theater (your shoe box) by covering it with colorful construction paper.

5 Cut a small hole (about ¾ inch wide by ¾ inch high) in one end of the box. (This is the hole you will look through.)

6 Cut another hole (about 3½ inches wide by 2½ inches high) in the opposite end of the box. (This hole will allow the light to shine through so you can see the movie.)

7 Cut two slots in the bottom of the box (about ¼ inch by 4¼ inches) towards the end with the large hole (they should be wider than the movie strip so the strip can slide through them). These slots will hold the movie strip in position while you view it.

8 Punch two holes in the sides of the box, near the top, towards the end where the large hole is. These holes are for the pencil or stick) that holds one end of the movie, as shown.

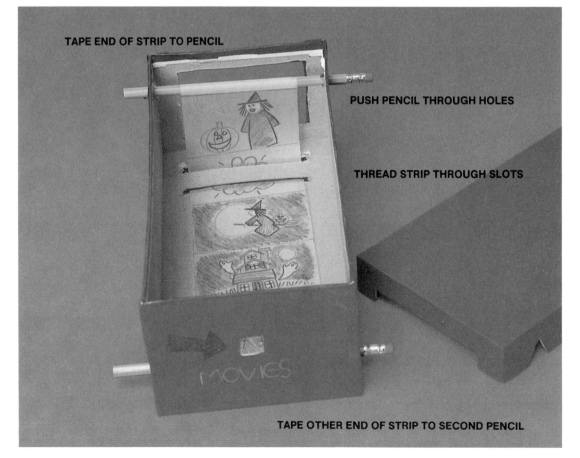

TAPE END OF STRIP TO PENCIL

PUSH PENCIL THROUGH HOLES

THREAD STRIP THROUGH SLOTS

TAPE OTHER END OF STRIP TO SECOND PENCIL

9 Punch two holes in the sides of the box, near the bottom, towards the end where the small hole is. These holes are for another pencil (or stick) that holds the other end of the movie, as shown.

10 Put pencils (or sticks) through the holes, as shown. These are the handles for the movie strip.

11 Wrap the end of the strip around the pencil (or stick) nearest to the small hole.

12 Thread the movie strip through the slots and tape the top end of the strip to the other pencil (or stick), as shown. (You should be able to see the first frame in front of the large hole.)

13 Put the lid on the shoe box. Hold the box up to a light and while looking through the small hole, carefully turn the pencil at the far end. The strip will roll by, frame by frame — watch as your movie comes to life!

Lights! Camera! Action!

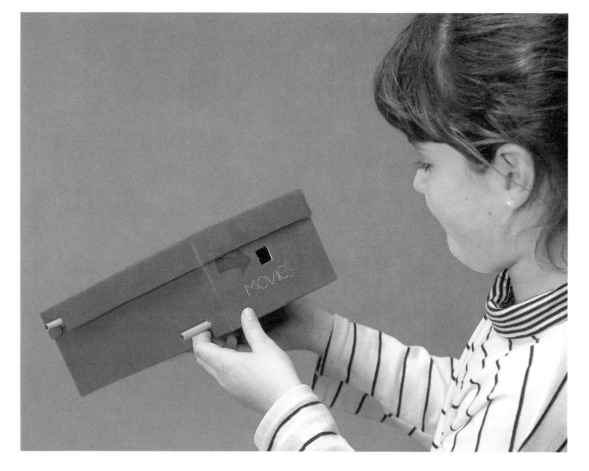

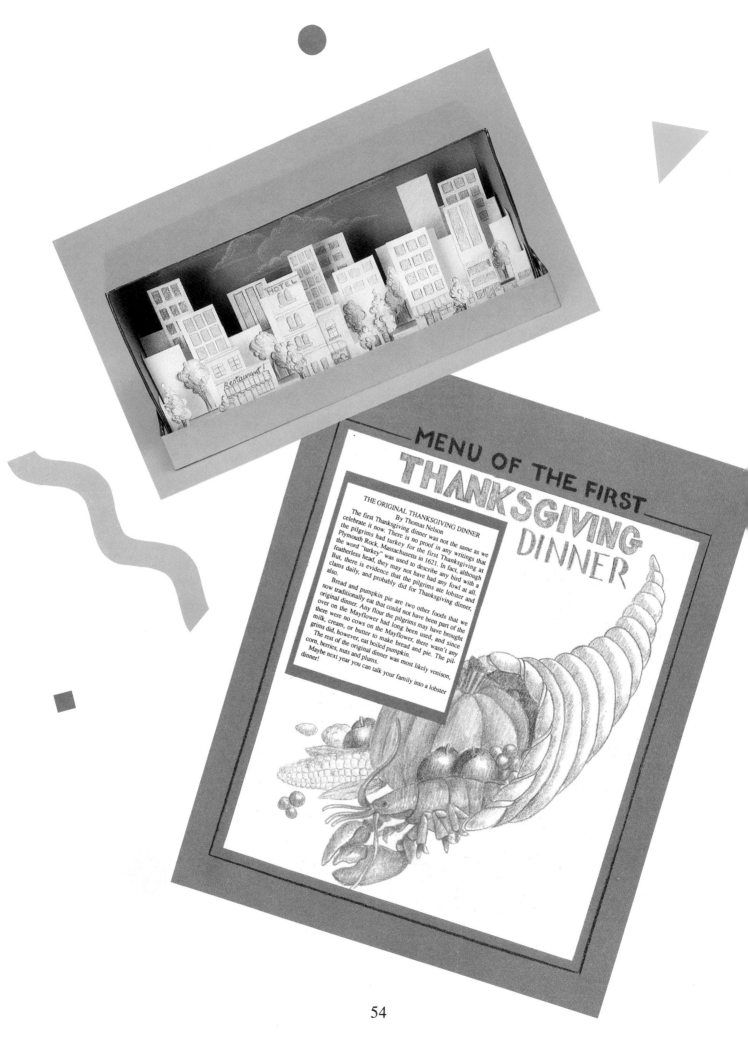

MENU OF THE FIRST THANKSGIVING DINNER

THE ORIGINAL THANKSGIVING DINNER
By Thomas Nelson

The first Thanksgiving dinner was not the same as we celebrate it now. There is no proof in any writings that the pilgrims had turkey for the first Thanksgiving at Plymouth Rock, Massachusetts in 1621. In fact, although the word "turkey" was used to describe any bird with a featherless head, they may not have had any fowl at all. But, there is evidence that the pilgrims ate lobster and clams daily, and probably did for Thanksgiving dinner, also.

Bread and pumpkin pie are two other foods that we now traditionally eat that could not have been part of the original dinner. Any flour the pilgrims may have brought over on the Mayflower had long been used, and since there were no cows on the Mayflower, there wasn't any milk, cream, or butter to make bread and pie. The pilgrims did, however, eat boiled pumpkin.

The rest of the original dinner was most likely venison, corn, berries, nuts and plums.

Maybe next year you can talk your family into a lobster dinner!

54

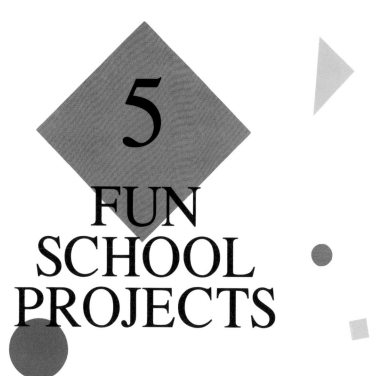

5
FUN
SCHOOL
PROJECTS

You may not think that school projects can be fun. But, have you ever tried coloring a photocopy to use in a report? It can be a lot of fun and it looks great! Or, have you ever researched the history of a holiday to see how it got started? In this chapter we have a surprise about the first Thanksgiving dinner.

You're about to find out that school projects can be fun!

One of the best ways we know to have fun doing a school project (and to get a good grade!) is to do something original. The next time you write a report you may want to color a photocopy of the subject. Teachers usually like the variety of something artistic, and they also appreciate the extra effort. You can have fun being creative!

Remember, as with all learning, you're limited only by your imagination. So be creative, and even when it's for school, **have fun!**

Flowers

You can learn about flowers (or any subject) while you have fun drawing them. What a fun school project!

1 Find some photographs of flowers that you like or that you are studying in school. A school text or an encyclopedia may have color pictures.

2 Photocopy the flowers you would like to use for your project. (You may want to make them larger or smaller.) Now you have a black and white version of the flowers that will be fun to color.

3 Using colored pencils, carefully color the flowers. Try to use colors that look like the examples in the book. You can color over the black areas with bright colors.

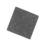

4 Cut out the flowers.

5 Display the flowers by arranging them and gluing them onto a piece of heavy construction paper or an art board.

6 Neatly letter the names of the flowers under the pictures.

What other subjects would be fun to photocopy and color? How about tropical fish, birds, or dinosaurs?

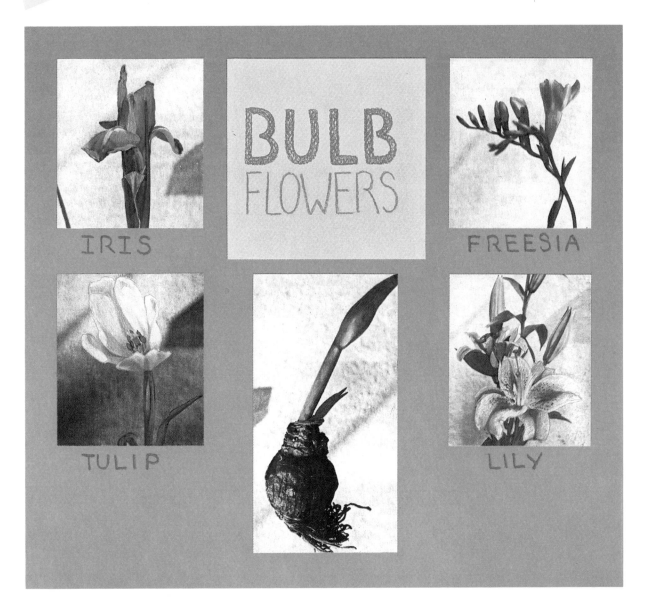

Thanksgiving School Project

We chose to tell the history of the first Thanksgiving dinner for our project, but you can use any part of any holiday or historical event you want to make this fun school project.

1 Plan the design of your poster before you draw or paste anything onto the paper.

2 Use light pencil to letter the poster. (See chapter 2.)

3 Use light pencil to draw the "horn of plenty" (cornucopia). Remember to leave plenty of room for your story.

4 Use colored pencils to trace over the light pencil lines.

5 Color in the solid areas of the drawing. Be sure to leave white areas for highlights.

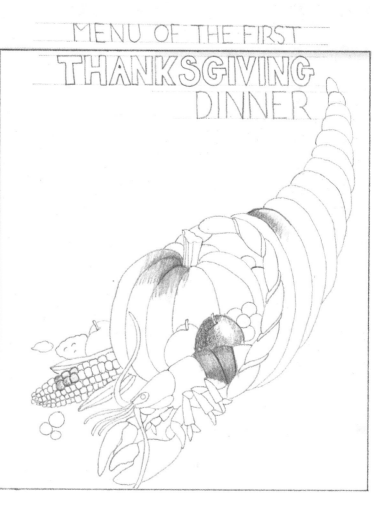

6 Color the shaded areas in a darker complementary color. We used two or three colors on each object to give them more shape and texture. We used yellow and brown for the horn of plenty; red and orange for the lobster; orange, yellow, red and brown for the pumpkin; purple and red for the plums; and yellow, brown and orange for the corn.

7 When the drawing looks the way you want, carefully erase any pencil lines that show.

8 Paste the story on the drawing. (To make your story neat, you may want to type it.)

What other holidays can you write about?

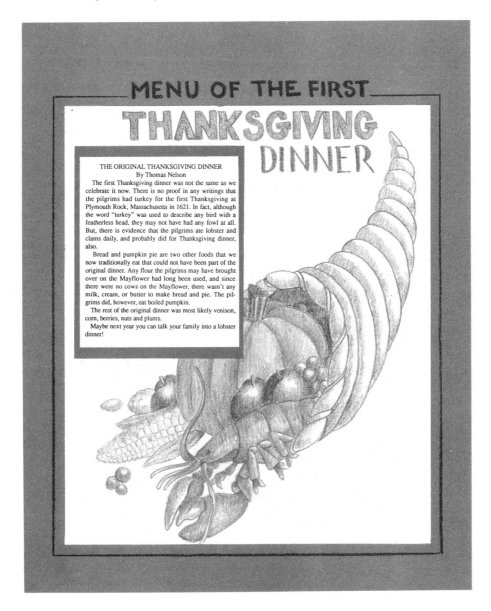

MENU OF THE FIRST
THANKSGIVING
DINNER

THE ORIGINAL THANKSGIVING DINNER
By Thomas Nelson

The first Thanksgiving dinner was not the same as we celebrate it now. There is no proof in any writings that the pilgrims had turkey for the first Thanksgiving at Plymouth Rock, Massachusetts in 1621. In fact, although the word "turkey" was used to describe any bird with a featherless head, they may not have had any fowl at all. But, there is evidence that the pilgrims ate lobster and clams daily, and probably did for Thanksgiving dinner, also.

Bread and pumpkin pie are two other foods that we now traditionally eat that could not have been part of the original dinner. Any flour the pilgrims may have brought over on the Mayflower had long been used, and since there were no cows on the Mayflower, there wasn't any milk, cream, or butter to make bread and pie. The pilgrims did, however, eat boiled pumpkin.

The rest of the original dinner was most likely venison, corn, berries, nuts and plums.

Maybe next year you can talk your family into a lobster dinner!

Cityscape Diorama

You can make a diorama of any subject you want. We made a cityscape. You can copy our example or use your own idea. (You will need a shoe box for this project. Be sure to ask permission if it doesn't belong to you.)

1 Find some books or magazines that have pictures of different cities. Decide what kind of city you want to use in your diorama.

2 Use light pencil to draw the buildings, streets, stores, trees, etc. Try to make them look realistic.

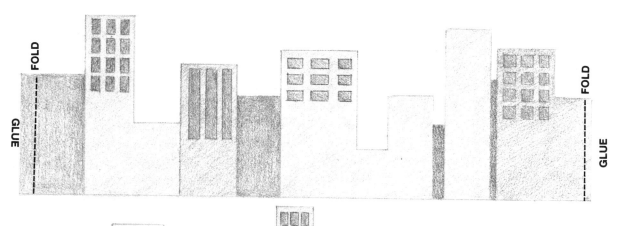

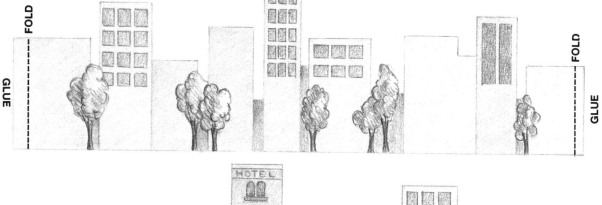

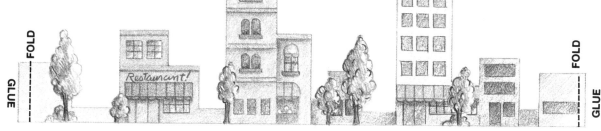

3 Trace over the pencil lines with colored pencils.

4 Add details with colored pencils and color in the solid background areas. When you have created the look you want, carefully erase any pencil lines that show.

5 Carefully cut out the parts. Be sure to leave an extra ¼ inch on the ends to glue to the box.

6 Cover the shoe box and the lid (which will be the base) inside and out with construction paper. You may want to draw clouds and the sky on the paper that goes on the inside of the box, as shown.

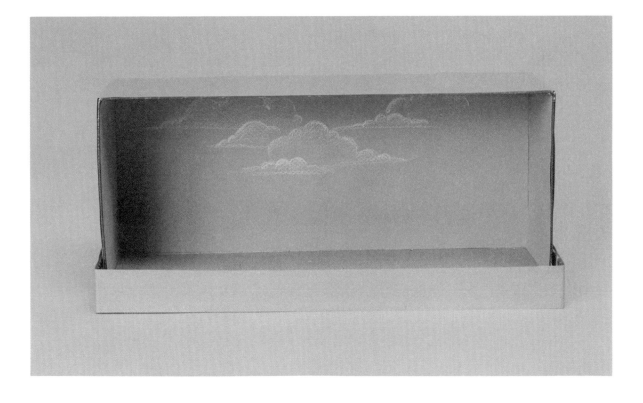

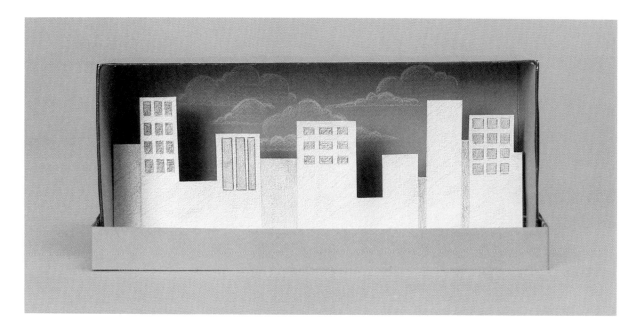

7 Glue the first layer (distant skyscrapers) to the back of the box. These are the things that are farthest away.

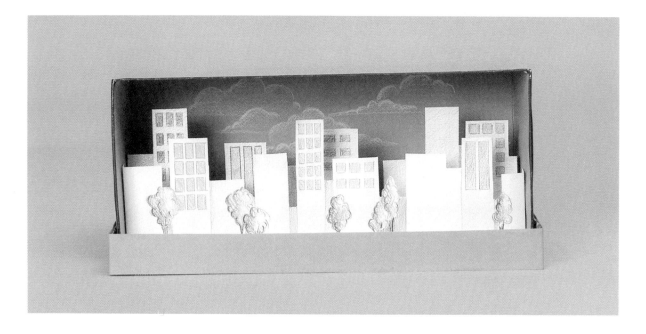

8 Glue the next layer (trees and more buildings) in front of the first layer by folding the sides of the paper (as shown), and gluing them to the sides of the box.

9 Glue the third layer (bushes, close-up stores, and buildings) by folding the edges of the paper and gluing them to the box in front of the second layer.

10 Glue any finishing touches onto the last layer of the diorama.

What a fun school project! I wonder what's cooking at that restaurant!

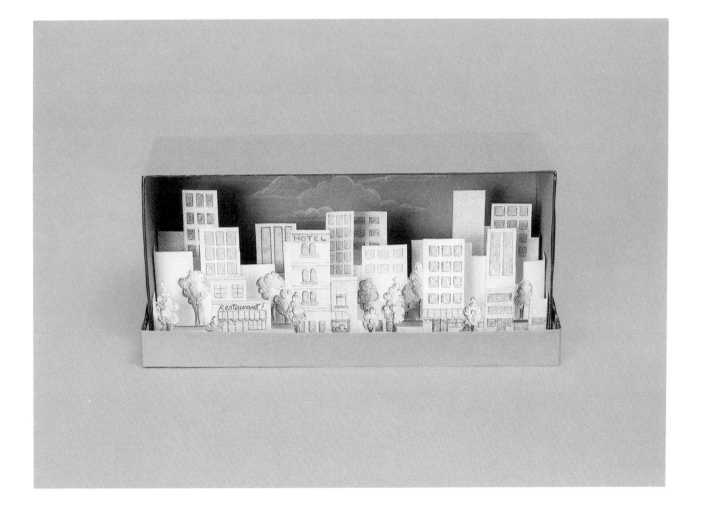

Beginners Art Series

Walter Foster's **Beginners Art Series** is a great way to introduce children to the wonderful world of art. Designed for ages 6 and up, this popular new series helps children develop strong tactile and visual skills while having lots of fun! Each book explores a different medium and features exciting "hands-on" projects with simple step-by-step instructions.

- **Drawing Fun** begins with basic shapes children know, and progresses to more advanced instruction on shading, shadows, and perspective.

- **Color Fun** teaches the fundamentals of color theory: color identification, color mixing, and color schemes. Using simple color wheels, children will learn how to use colors to create various effects.

- **Clay Fun** demonstrates clay sculpting techniques, and acquaints children with several different types of clay. Sculpting projects range from animals and clowns to a model of the solar system.

- **Comic Strip Fun** utilizes characters with interchangeable body parts to teach children how to draw facial expressions, body movements, and character interaction. "Hands-on" projects offer children the chance to create their own comic strips and single-frame comics.

- **Poster Fun** introduces basic design and lettering skills—centering, outlining, spacing—then shows children how to use these techniques to create posters, greeting cards, and games.

- **Paper Art Fun** teaches children how to make puppets, castles, papier-mache dinosaurs, and fish mobiles out of everyday materials such as construction and tissue papers, newspaper, and paper bags.

- **Cartoon Fun** teaches beginning artists how to use simple shapes to create cartoon characters. Instruction begins with the first steps of drawing faces and facial expressions, and progresses to the final development of a character with personality, movement, and props.

- **Painting Fun** teaches the fundamentals of painting—from choosing a color scheme to painting flat and three-dimensional art—using various types of paints.

- **Felt Tip Fun** demonstrates the use of a variety of felt tip and marker pens through projects ranging from two-dimensional art to a puppet and a diorama.

- **Colored Pencil Fun** offers a series of two- and three-dimensional art projects which help children learn fundamentals such as shading, color blending, and basic drawing.

- **Fabric Art Fun** is a wonderful tool for introducing beginning artists to three-dimensional art. It shows children how to make puppets, soft toys, decorations, greeting cards, and other fun projects out of common fabrics such as cotton balls, felt, yarn, nylon, and ribbon. It also includes projects in which children make "fashion statements" by painting on t-shirts, sweatshirts, tennis shoes, socks and shoelaces.

- **Craft Painting Fun** demonstrates how to decorate various three-dimensional objects with washable acrylic paints. Children will learn how to change ordinary household items such as plastic and glass bottles, old picture frames, paper bags, clothespins and cardboard into fun and useful works of art.